Horses at Work
A Coloring Book

Devin Lintzenich

DEVIN'S DESIGNS

2017

Copyright © 2017 by Devin Lintzenich

All rights reserved. This book or any portion thereof may not be reproduced or used in any manner whatsoever without the express written permission of the publisher except for the use of brief quotations in a book review or scholarly journal.

First Printing: 2017

ISBN 978-1-365-81517-1

Devin's Designs
devins.designs@gmail.com
www.devinsdesigns.myportfolio.com

Ordering Information:

Special discounts may be available on quantity purchases by corporations, associations, educators, and others. For details, contact the publisher at the above listed address.

U.S. trade bookstores and wholesalers: Please contact Devin's Designs

Dedication

This coloring book is dedicated to my family and friends, who have put up with my nearly constant drawing, talking, reading, writing, dreaming, and riding of horses for going on 20 years. Someday, it's all going to pay off. Thank you for loving me anyway.

About this Book

I taught myself how to draw horses almost as early as I could hold a crayon, with various degrees of success. Eventually, I got to be okay at it, but I also learned that most people, even those who draw, don't draw horses. But that's all I ever wanted to draw.

So perhaps it's not surprising that the idea of creating a coloring book about horses has been floating around in my head for a long time. Before, in fact, coloring books became popular again. I just wasn't sure what kind of horse coloring book I wanted to create.

It came to me when I was looking at coloring books to purchase for myself, that so many of them depict whimsical, fantasy pictures of horses to color, or majestic horses running free, and few depict horses doing the things that I, an equine professional, see them doing every day. Thus, Horses at Work was born in my head, and now it's put on paper to share with the world.

My hope is that you enjoy coloring these pages as much as I enjoyed creating them.

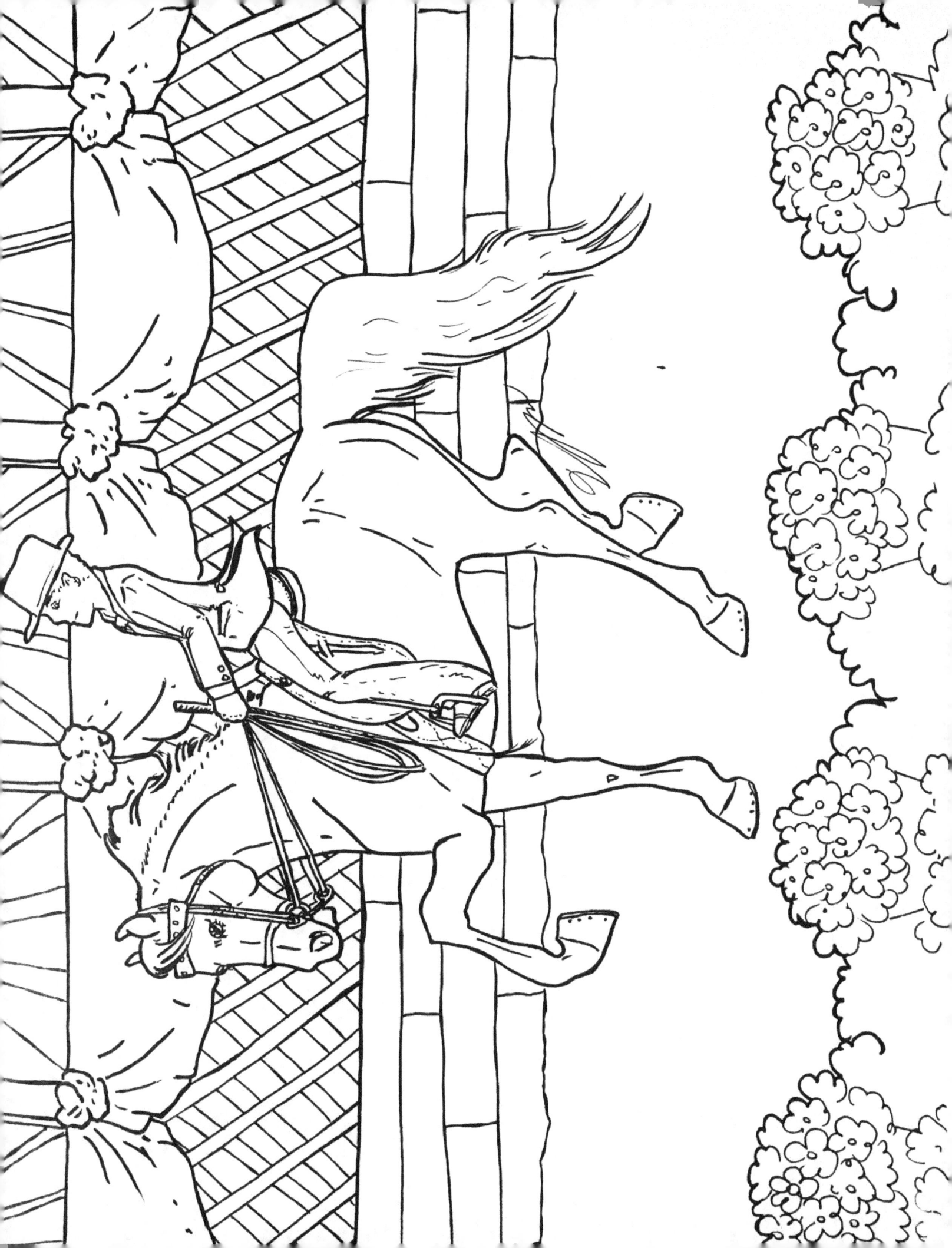

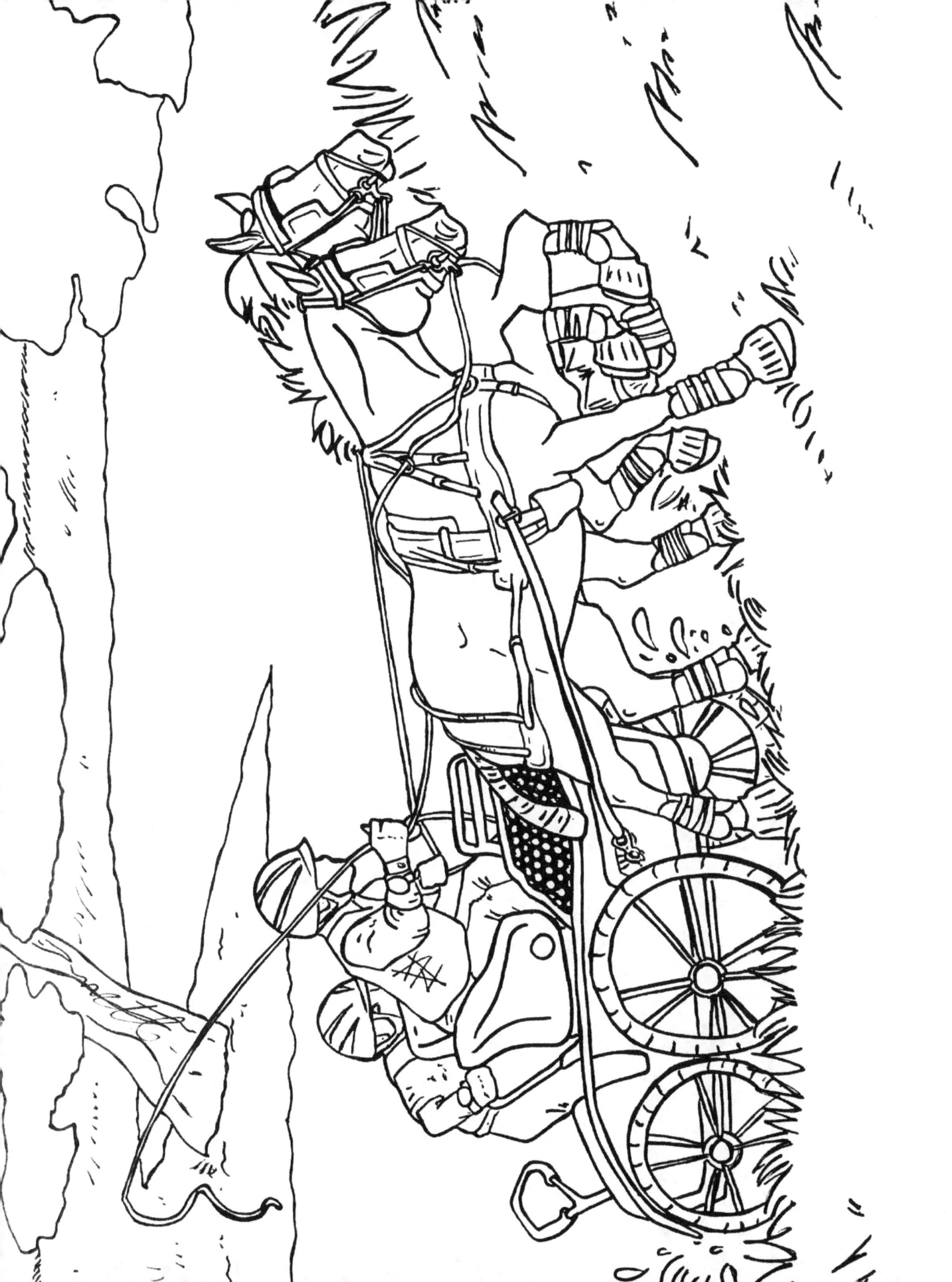

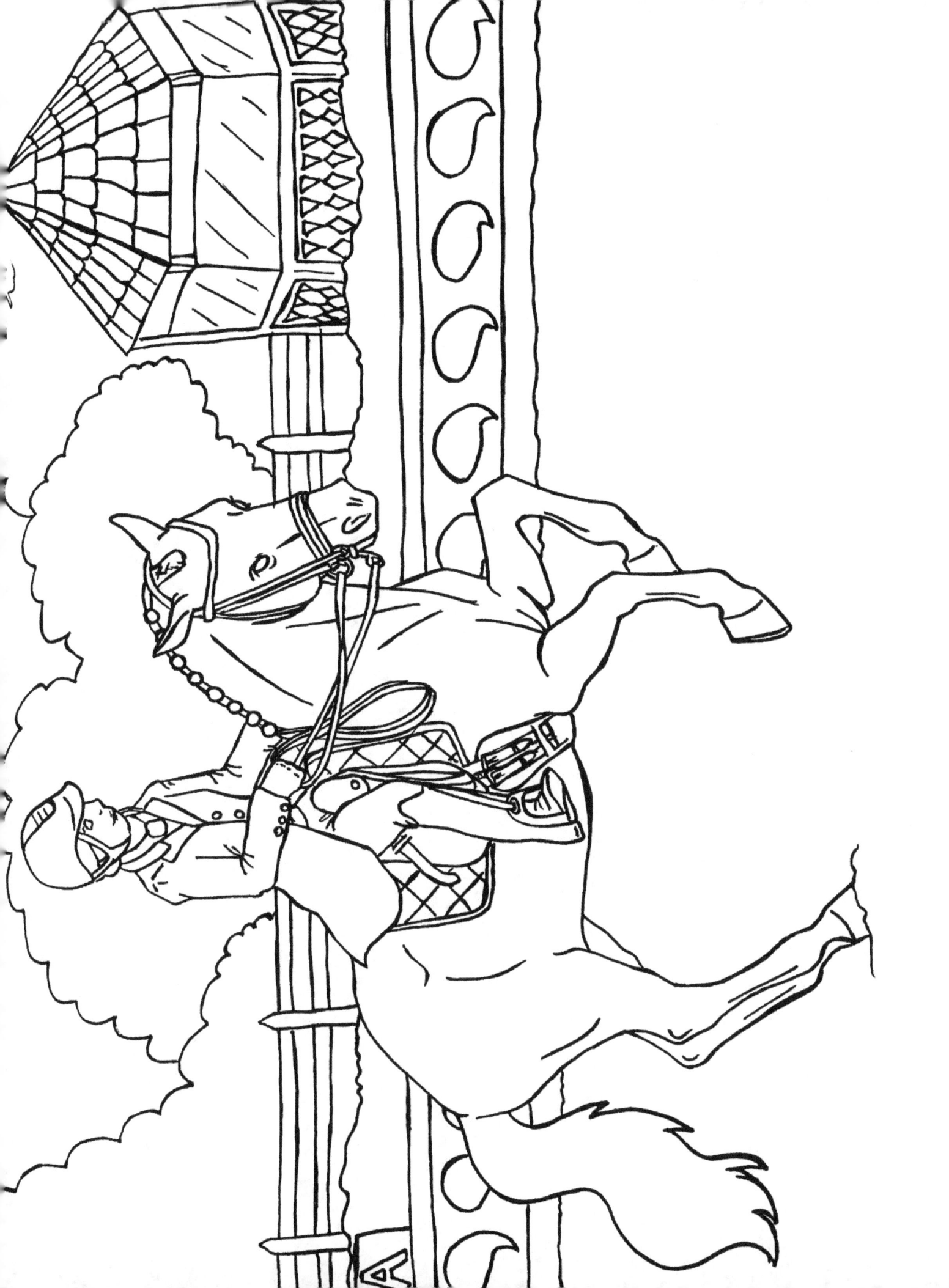

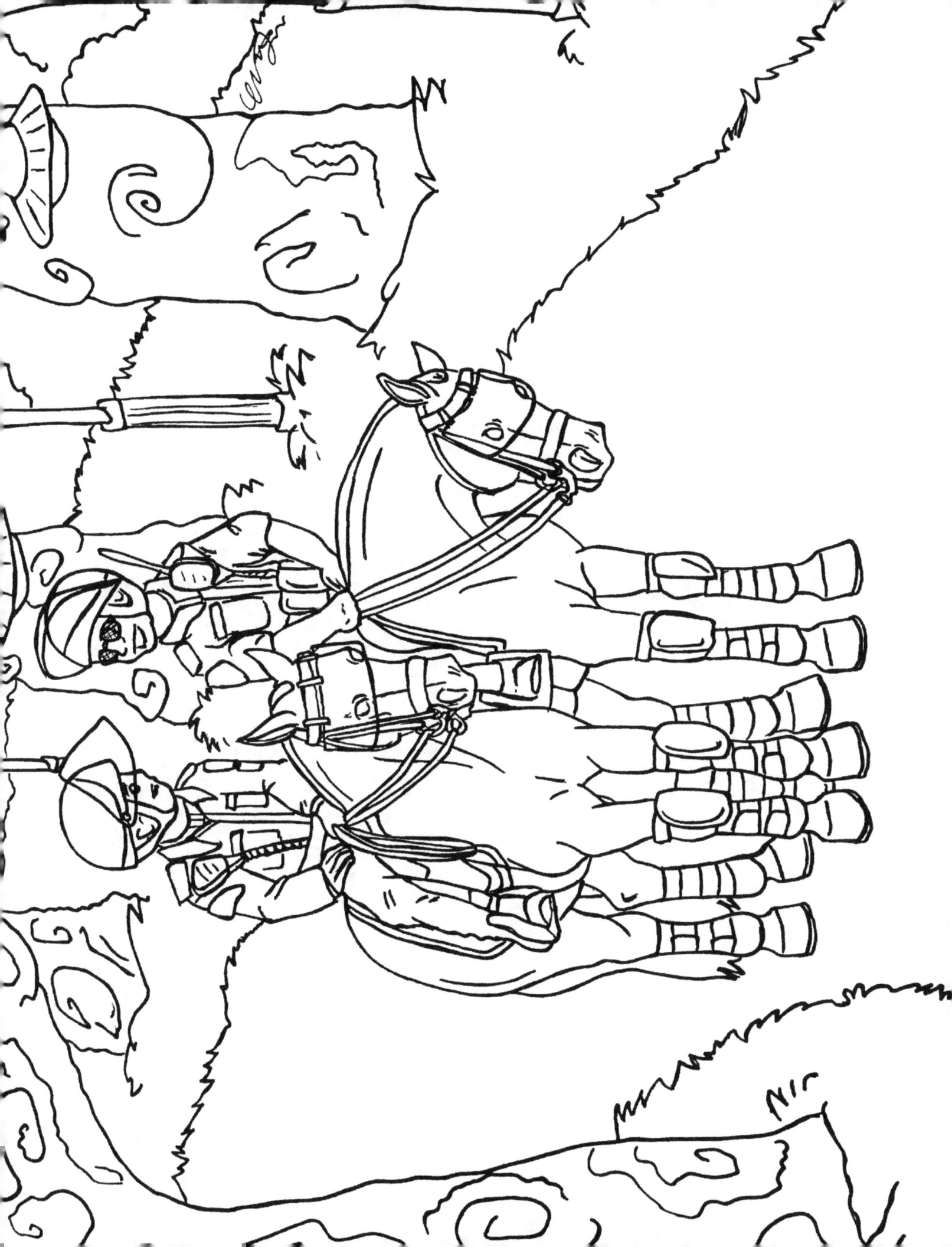

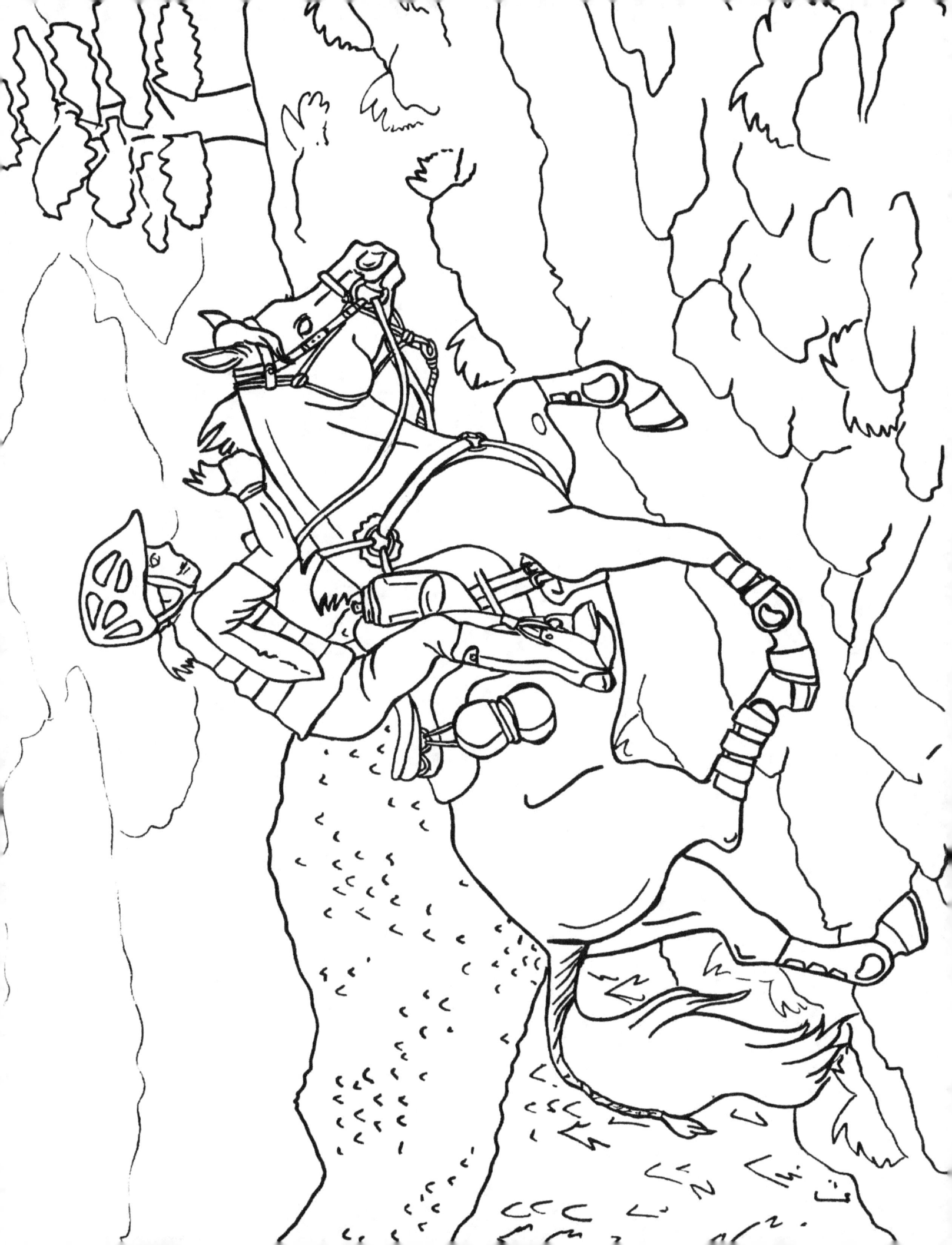

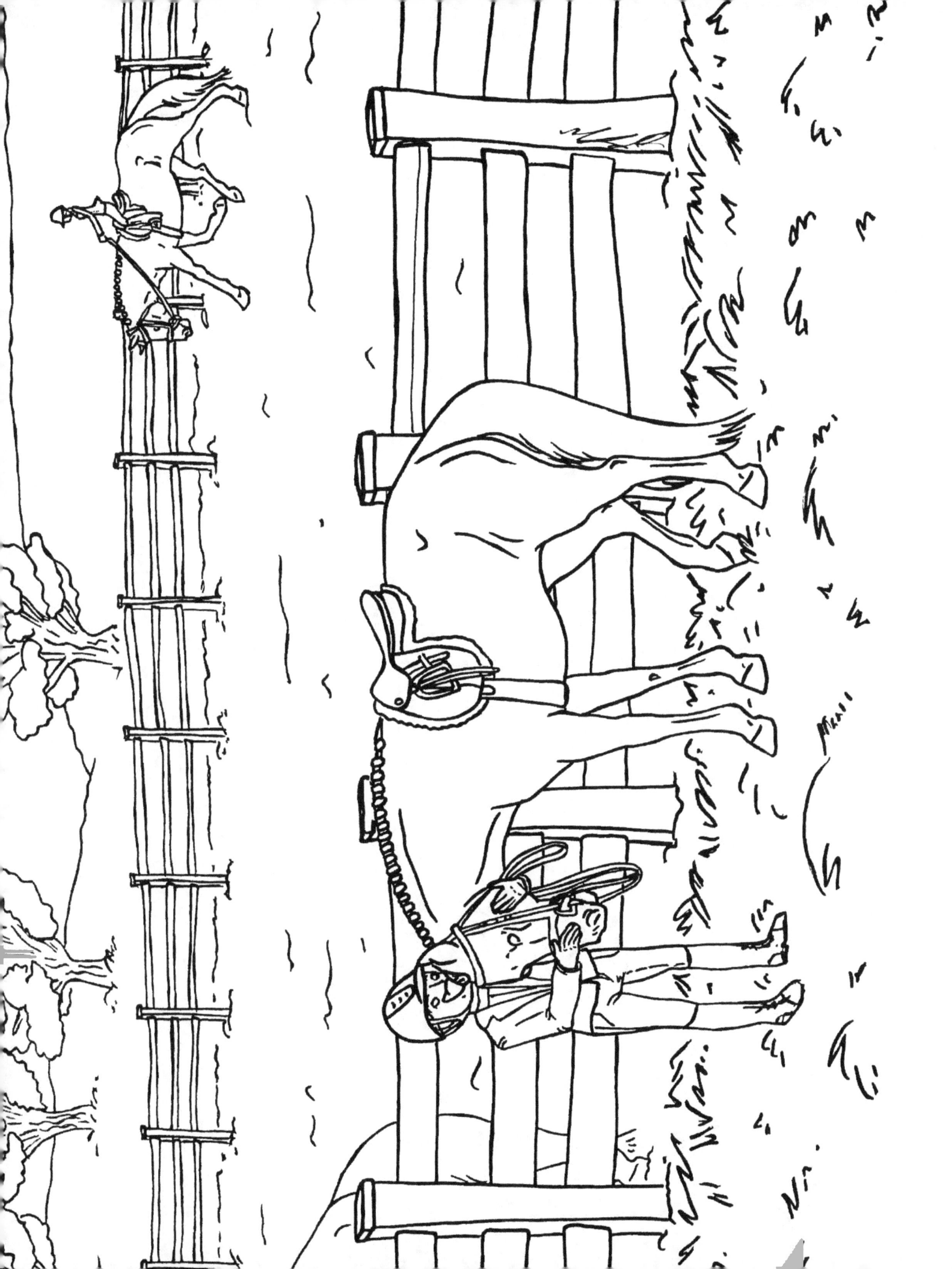

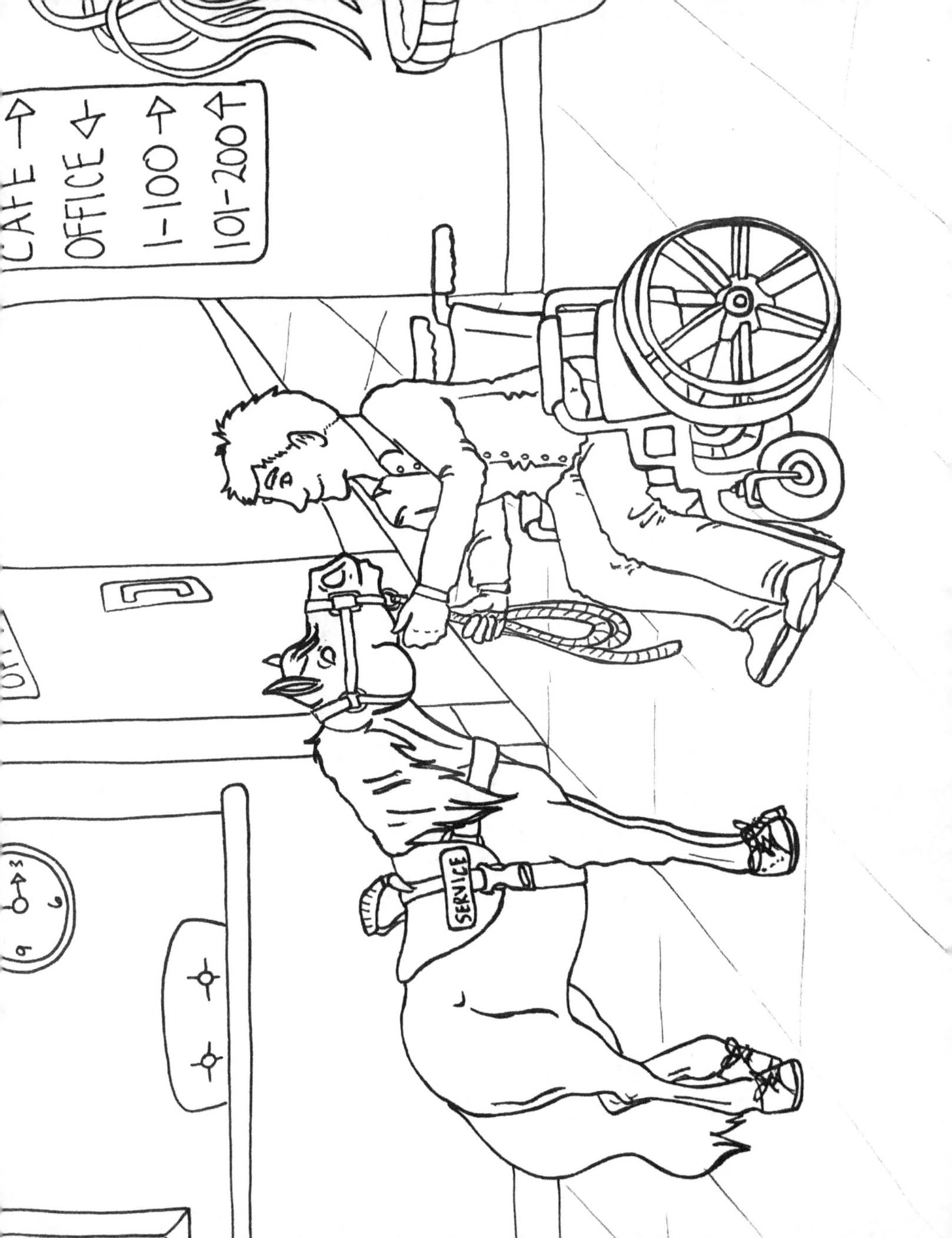

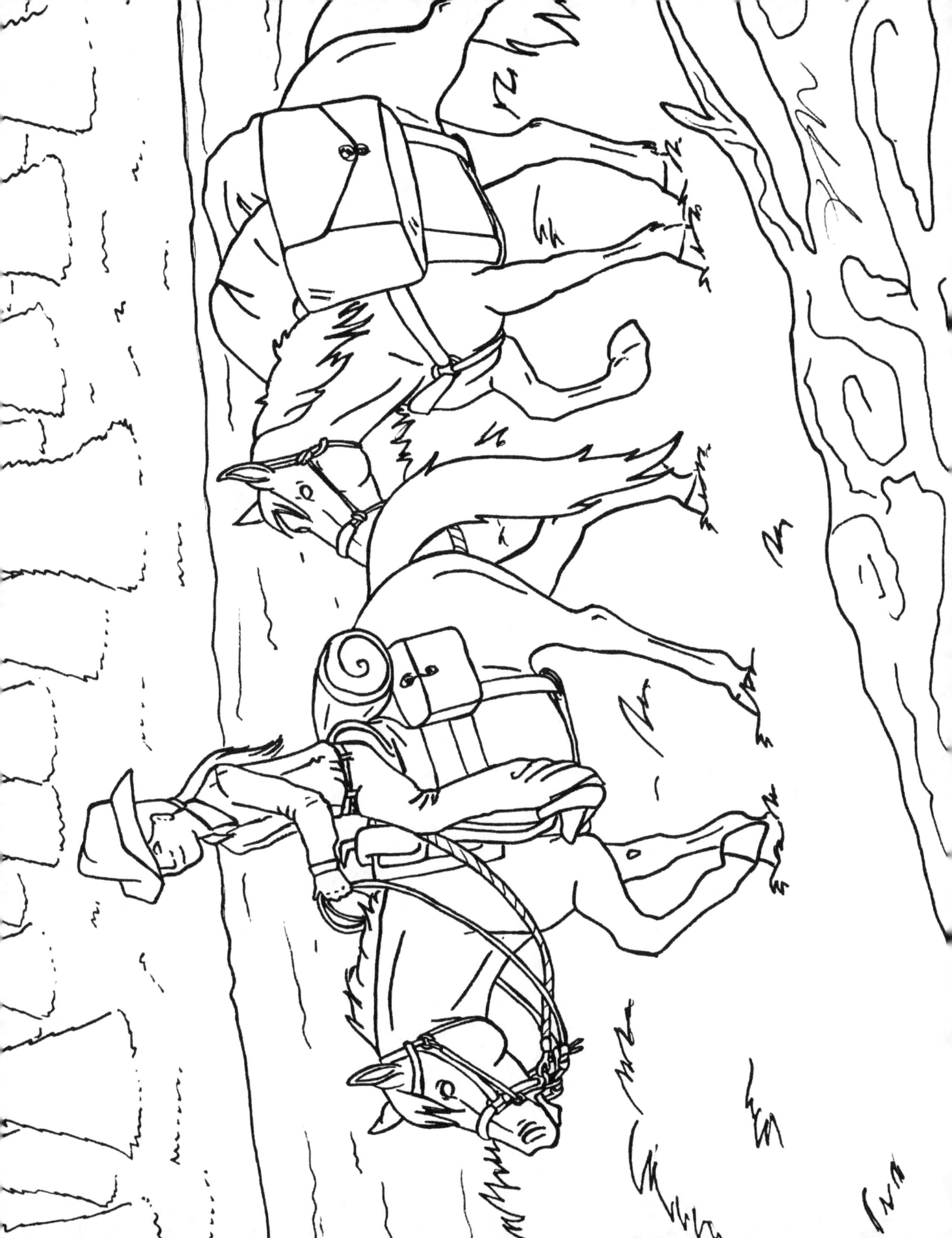

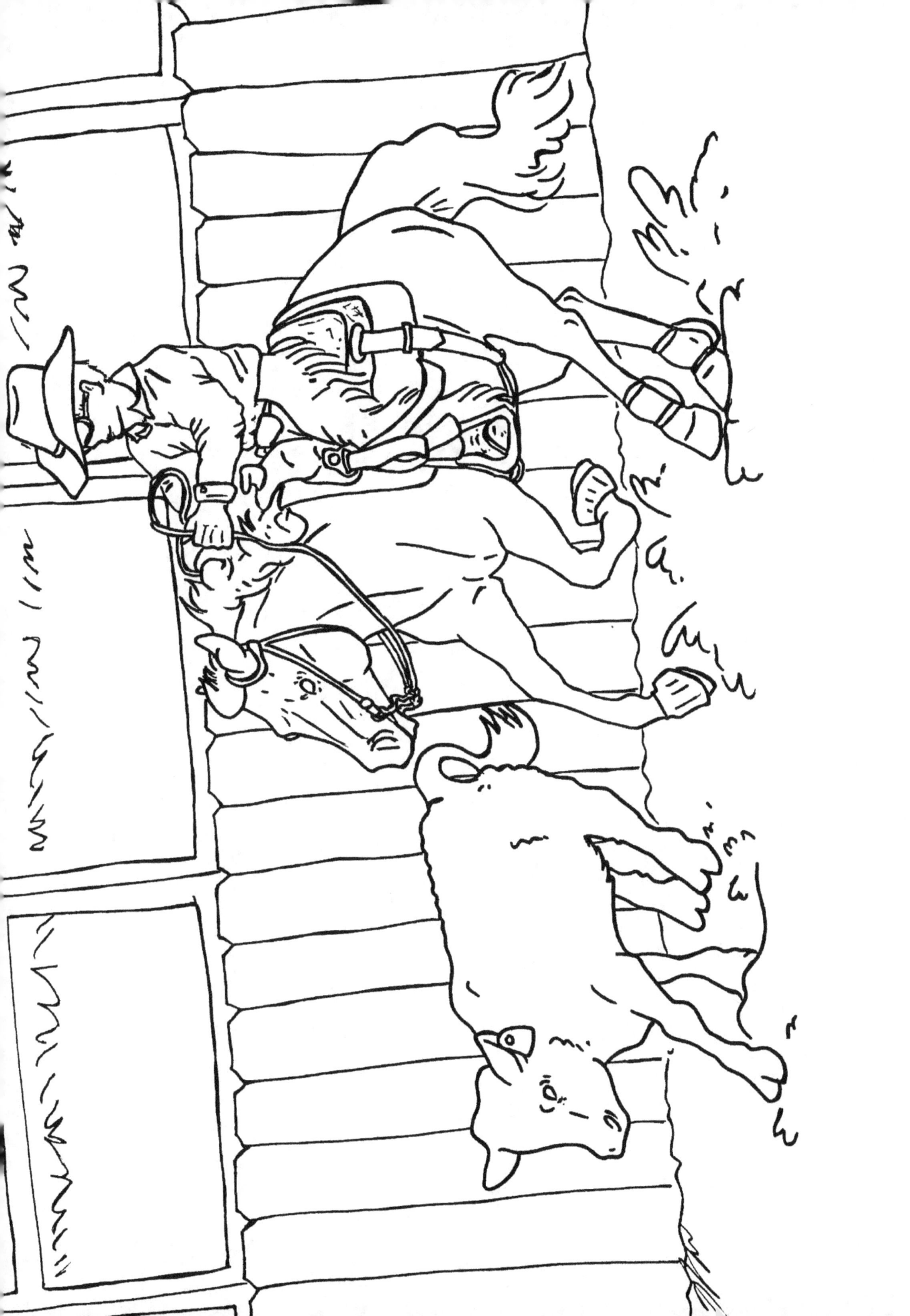

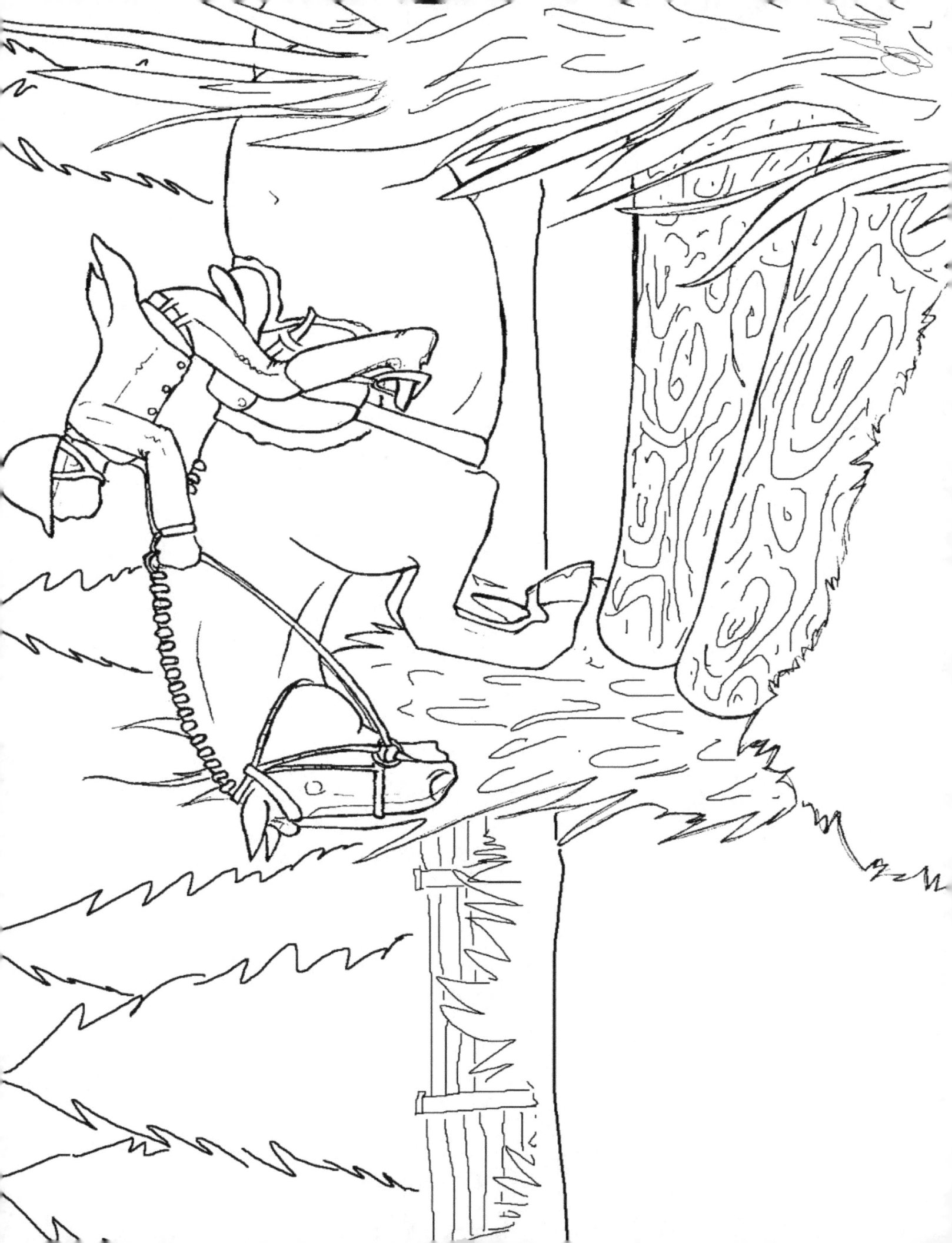

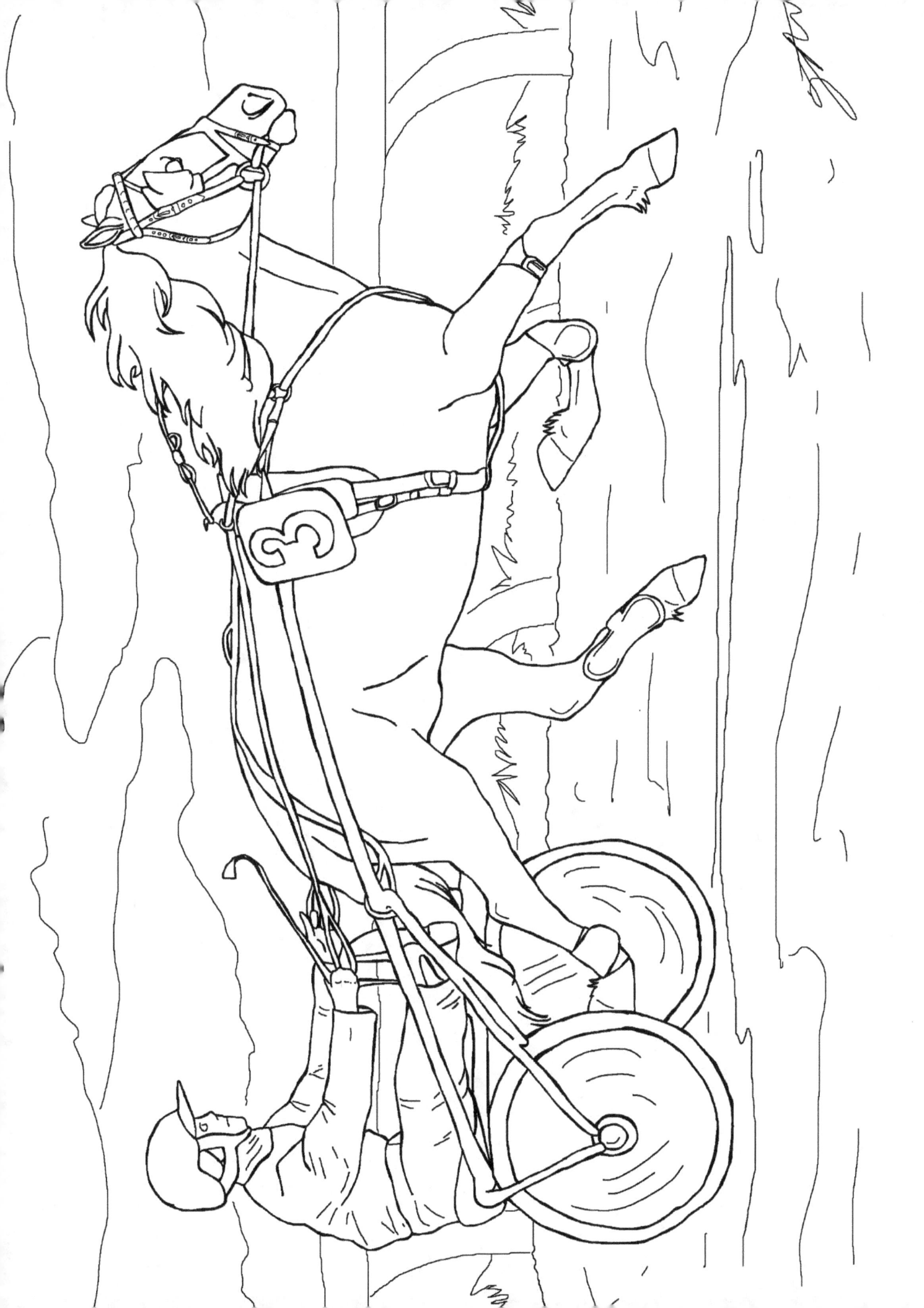

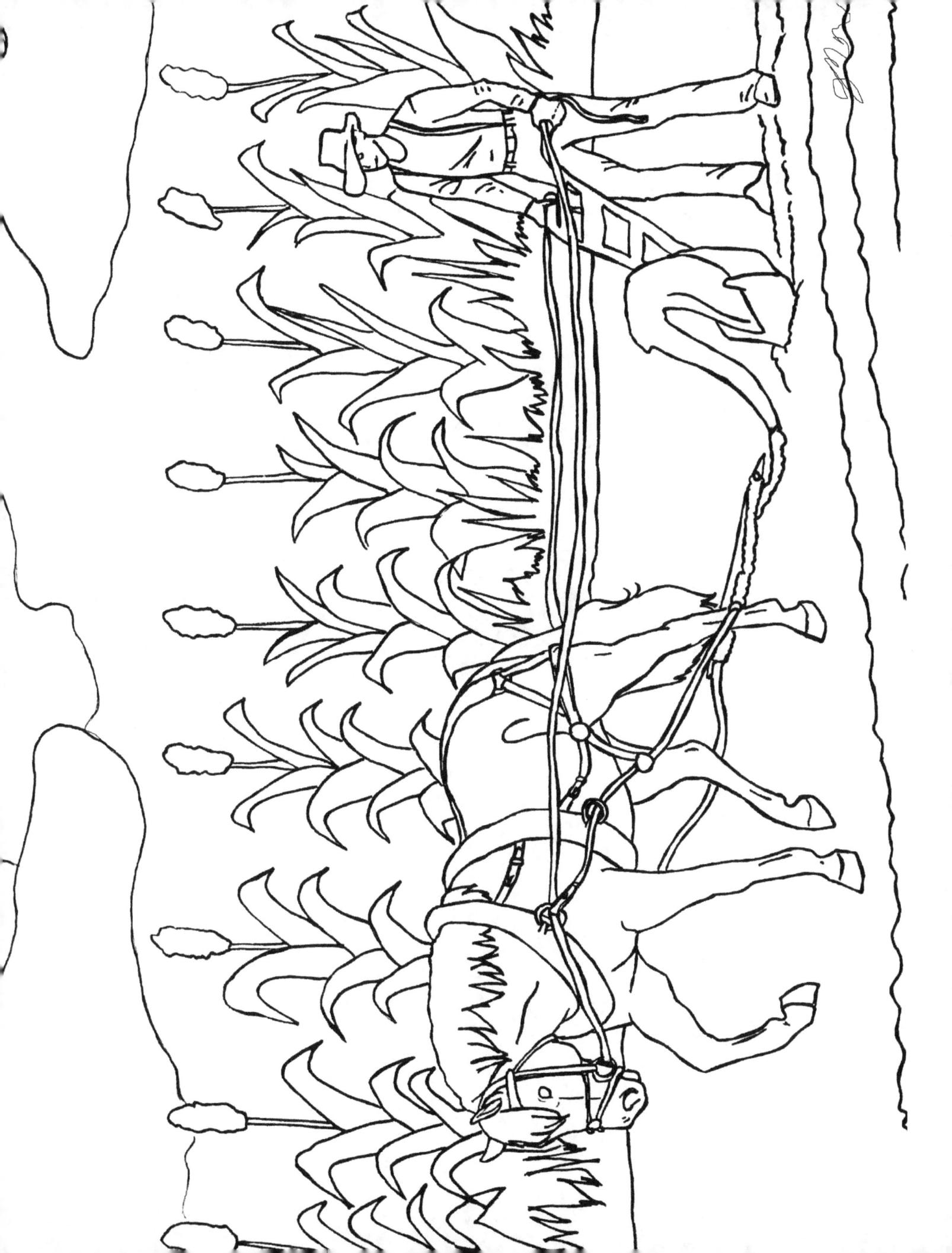

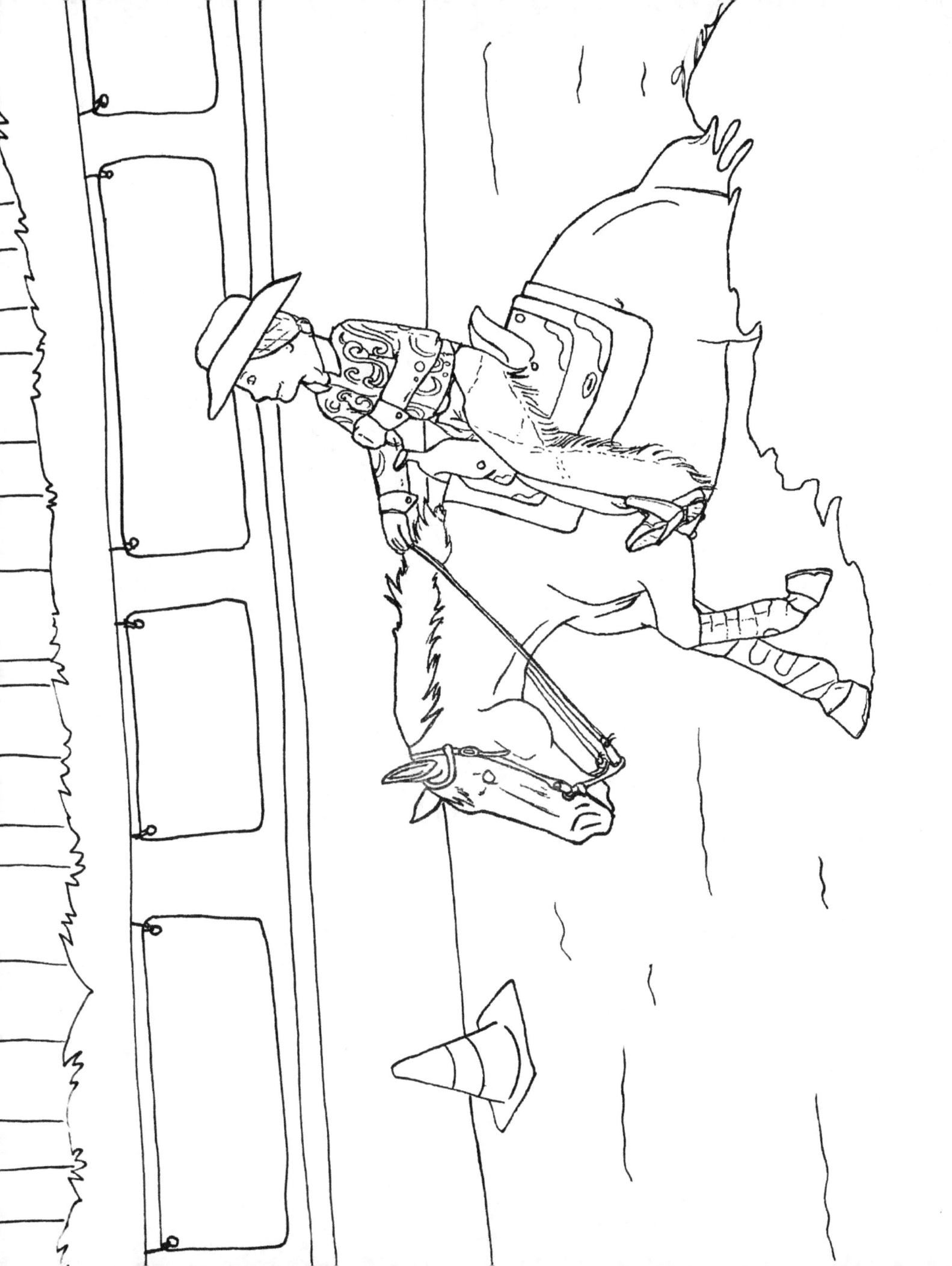

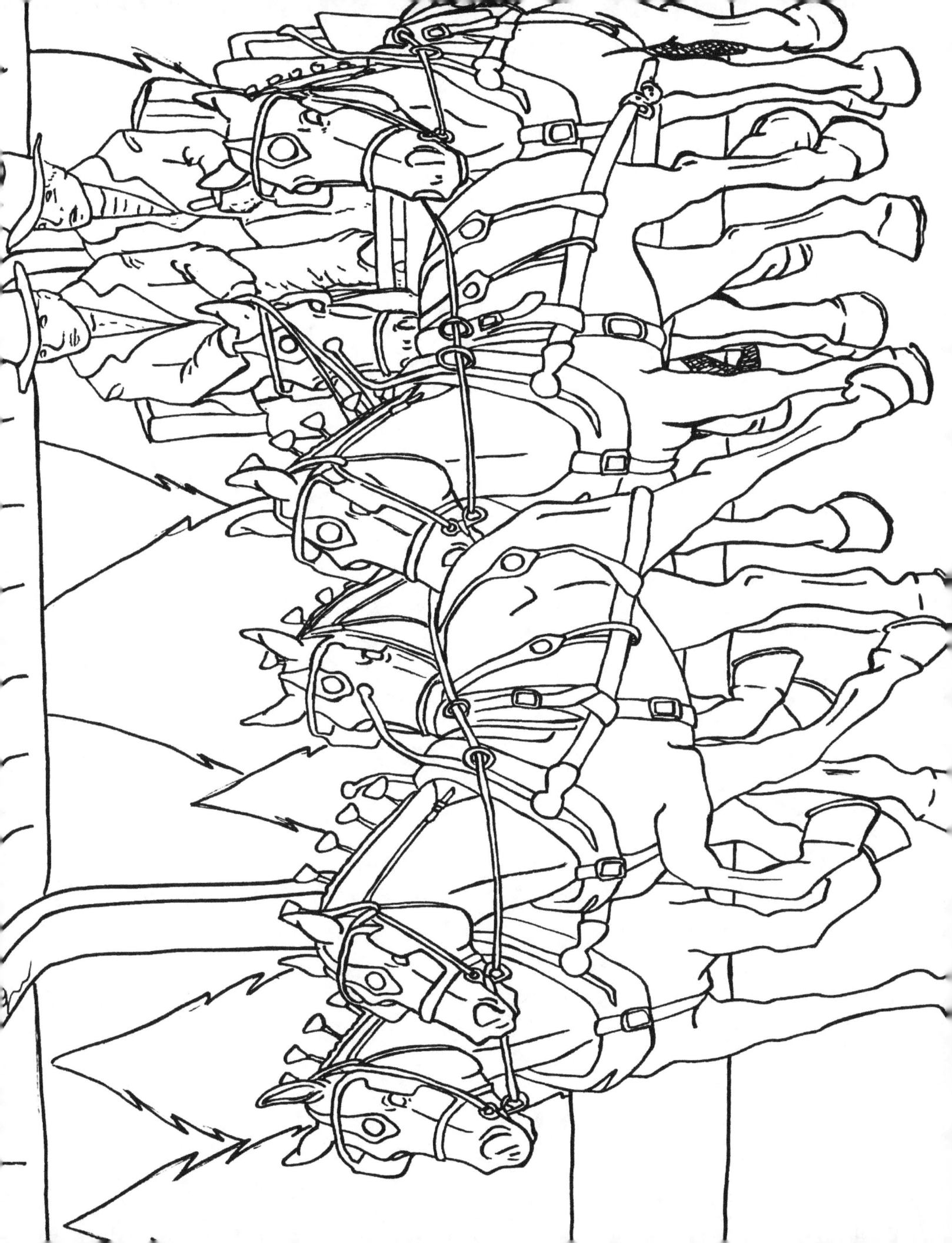

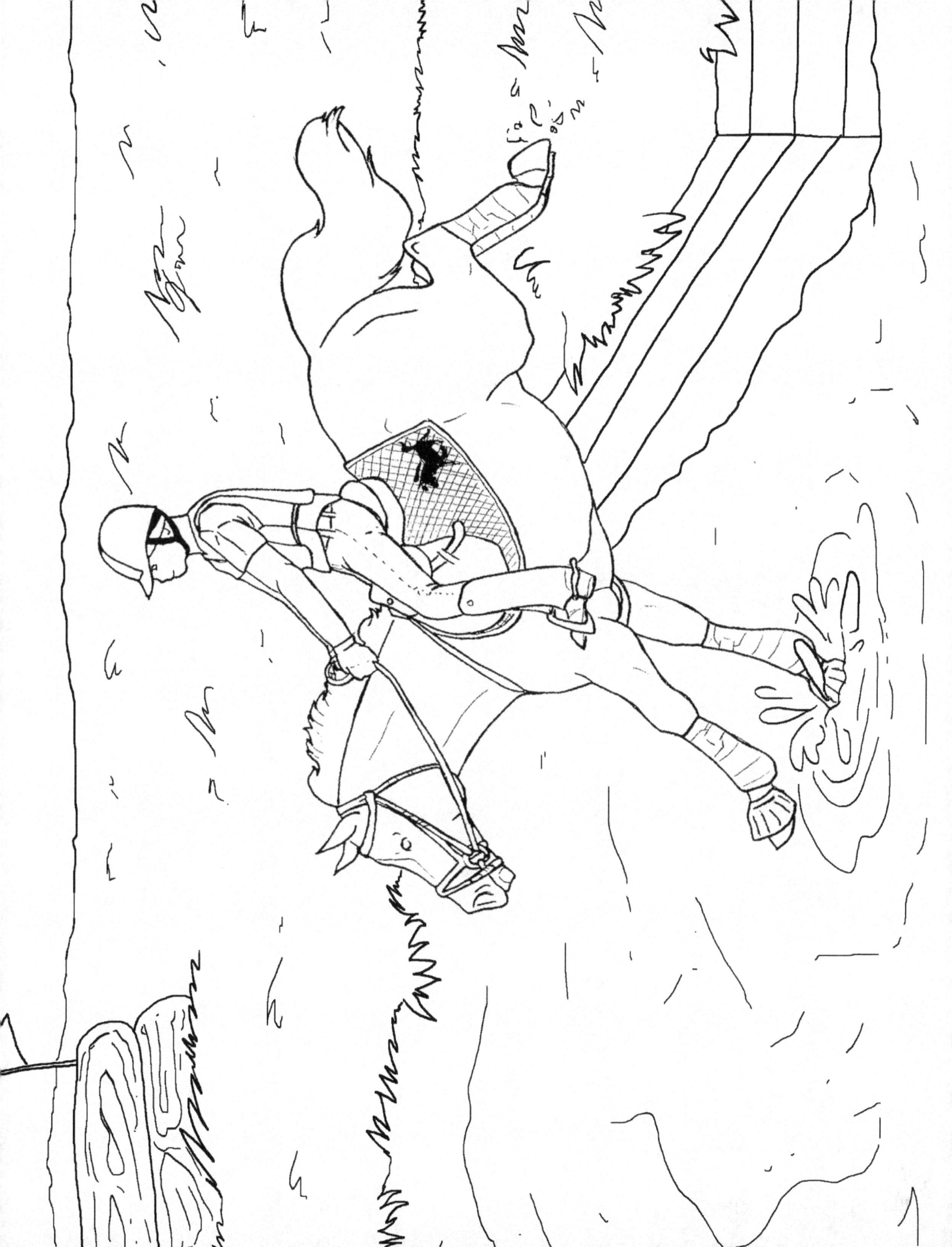